Dedicated to all aspiring photographers
whose vision is bigger than what their eyes can see.

You don't have to be Tall or Short to take a picture
You don't have to be Big or Skinny to take a picture
You don't have to be Black or White to take a picture
You don't have to have Long or Short hair to take a picture.
Just Be YOU
Pick up a camera
and take a picture!
The beauty is whatever you capture.
You wont regret it.

- CJ Reaves

There is no limit to how BIG your vision is!

POINT & SHOOT

With Taj and Cam!

Written by: **CJ REAVES**

Illustrated by: **HAYLEY MOORE**

Help Taj on
his mission
to take

10

pictures!

What you'll need:

- A camera or phone to take pictures

- Adult Supervision

- Tape or Glue

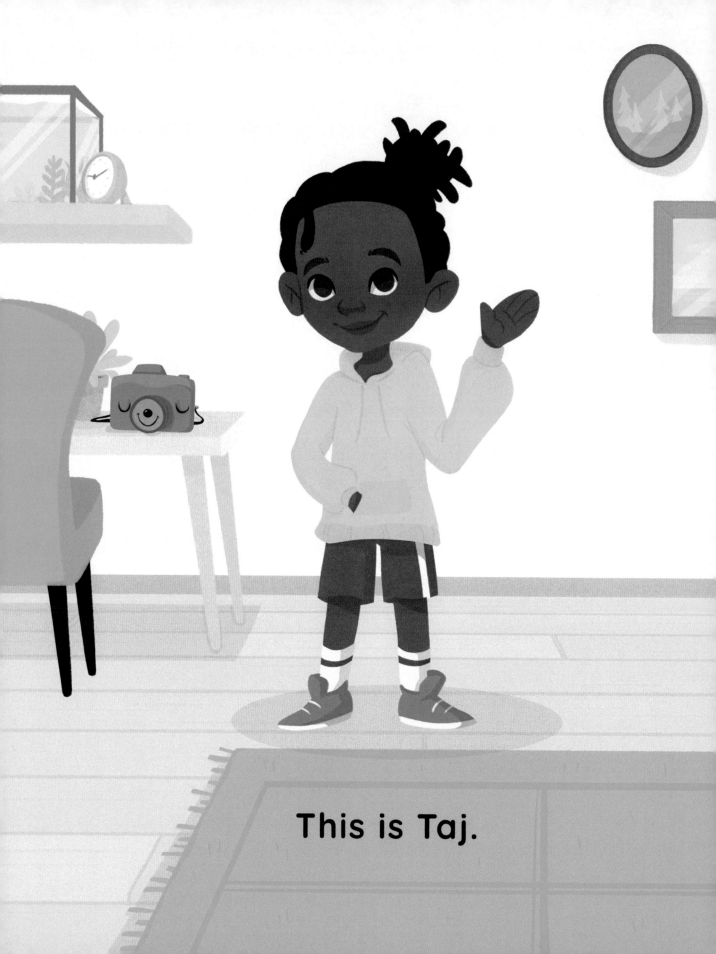

This is Taj.

This is Cam,
Taj's digital camera.

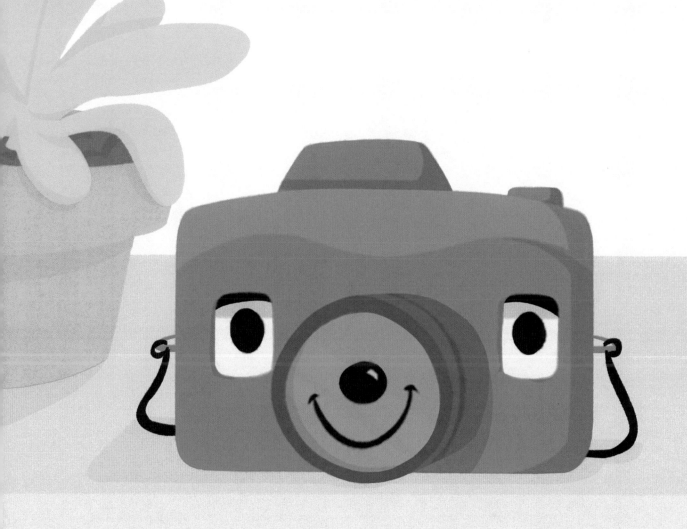

Taj likes to take pictures with Cam.

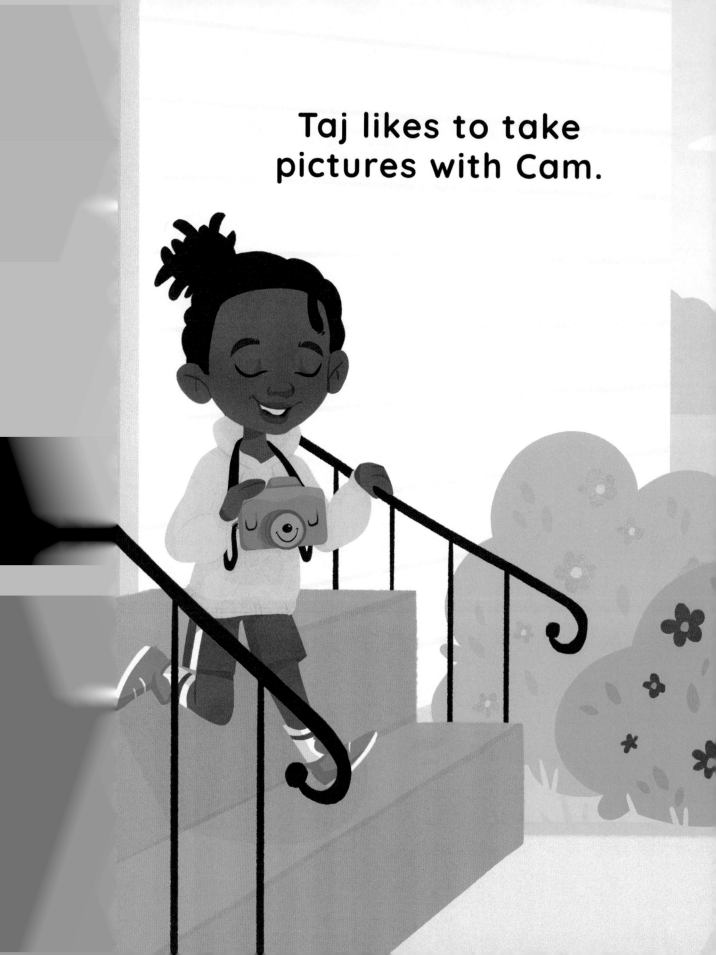

Let's help
Taj and Cam
capture **10** photos
on their
photography
journey!

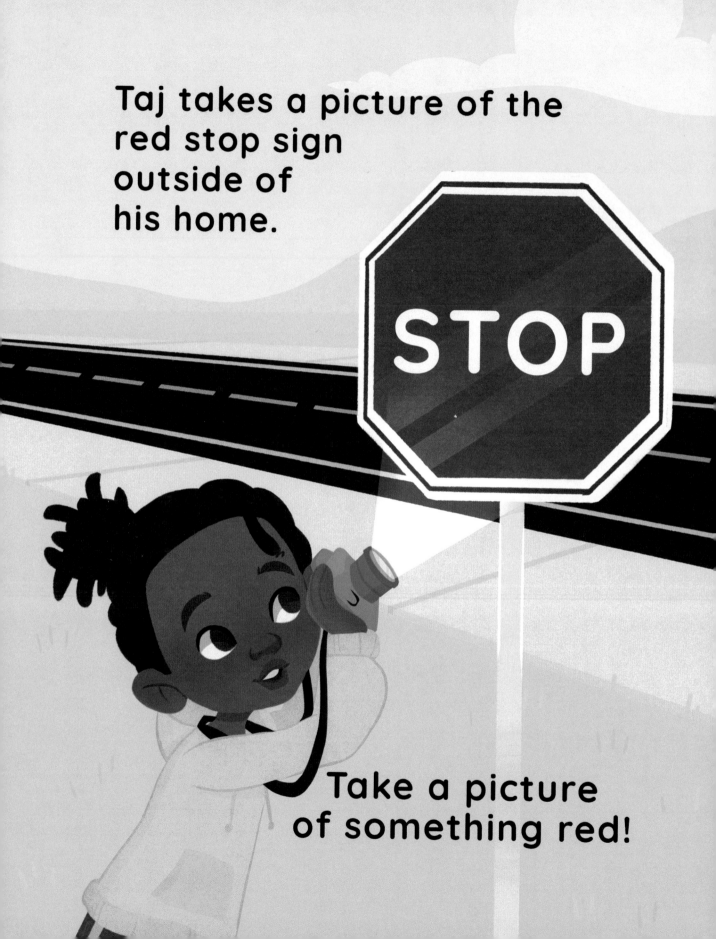

Taj takes a picture of the red stop sign outside of his home.

Take a picture of something red!

**Tape your picture of
something <u>red</u> here**

Taj has completed his
first photo assignment!
Next is a picture of his house.

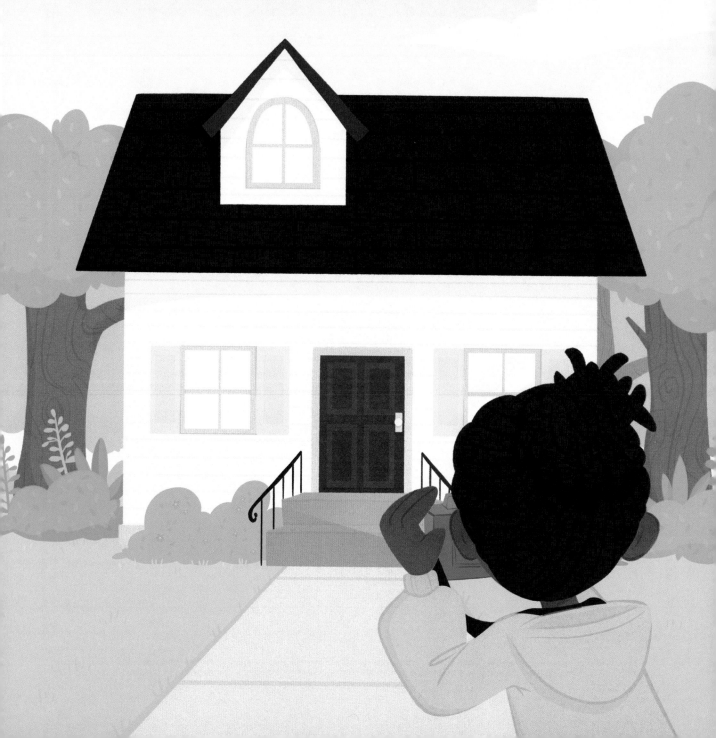

Tape your picture of
your <u>house</u> here

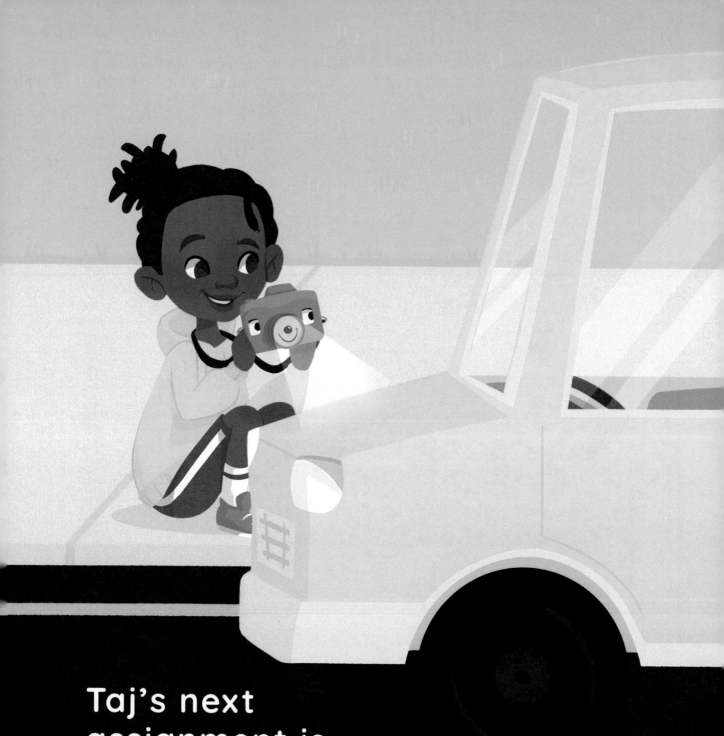

Taj's next
assignment is
to take a picture of
a vehicle. His parents have their
car parked next to their home.

Tape your picture of
a vehicle here

Taj may not be hungry, but he really loves food,

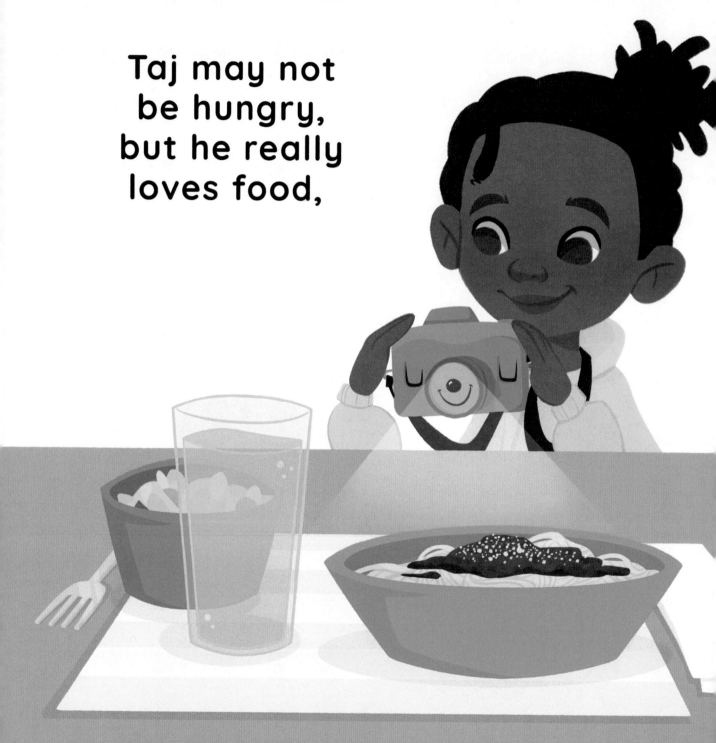

which is his next assignment.

Tape your picture of
food here

Taj likes the way trees look, but Cam shows him how beautiful flowers can be on camera. He takes a picture of both in one shot.

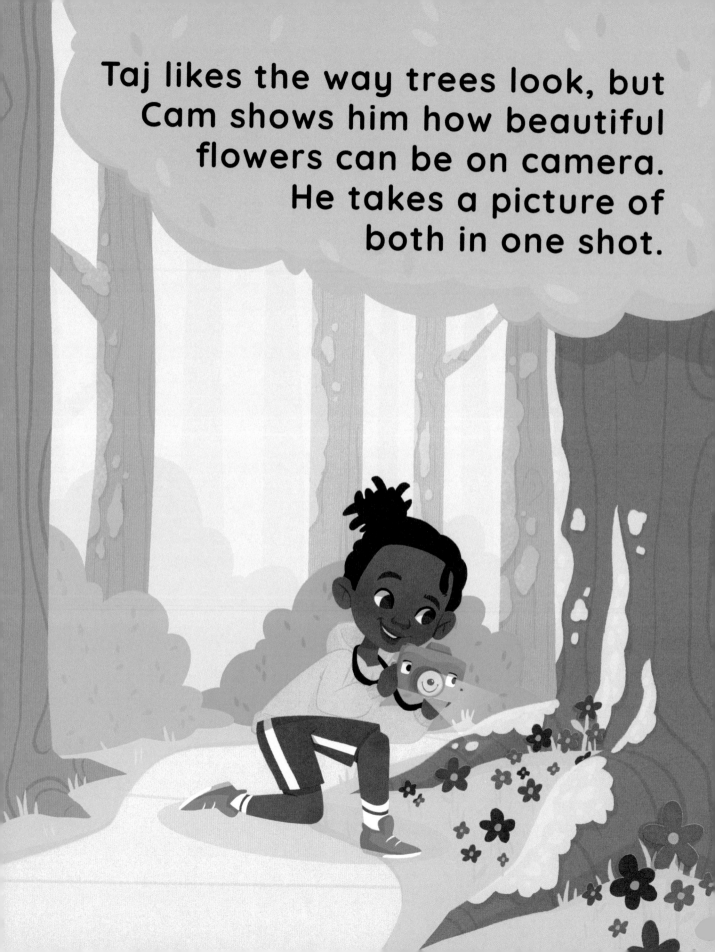

Tape your picture of
a tree with flowers here

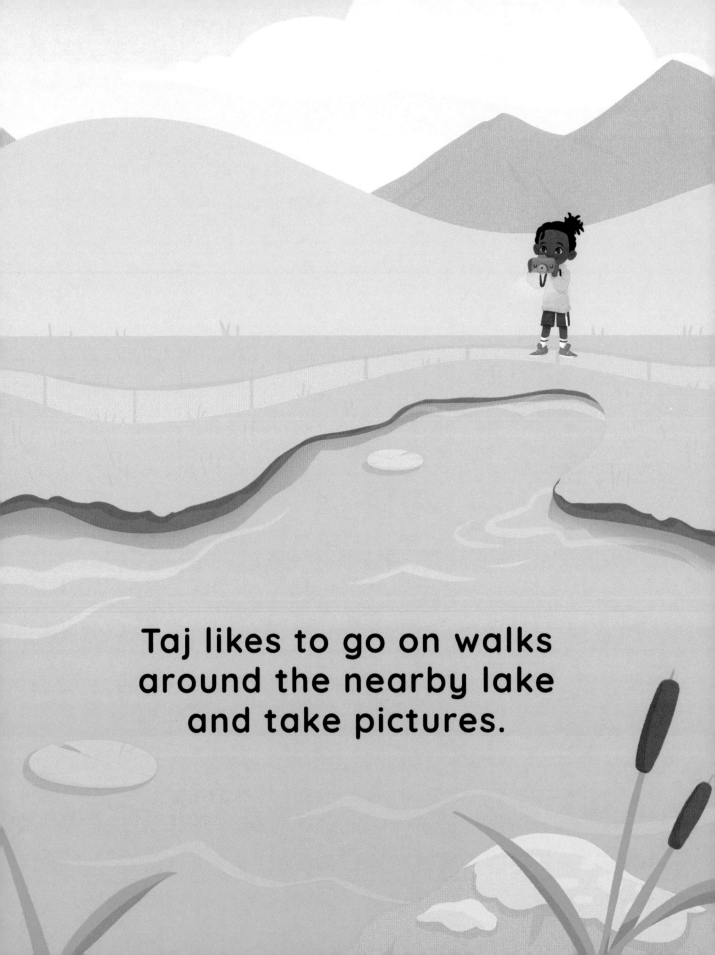

Taj likes to go on walks
around the nearby lake
and take pictures.

Tape your picture of
a body of water here

Taj really loves nature, especially the wild animals.

He loves taking photos of birds, squirrels, and lizards.

Tape your picture of
an animal here

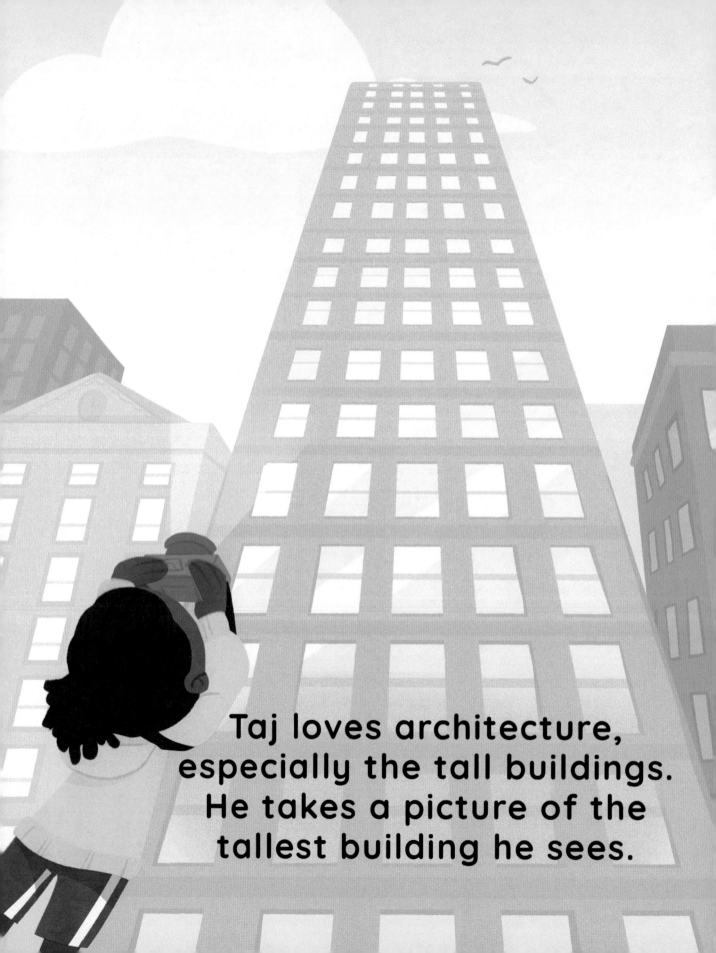

Taj loves architecture,
especially the tall buildings.
He takes a picture of the
tallest building he sees.

Tape a picture of the tallest
building you can find here

Like most kids, Taj enjoys going to the playground. He takes a picture of his favorite piece to play on.

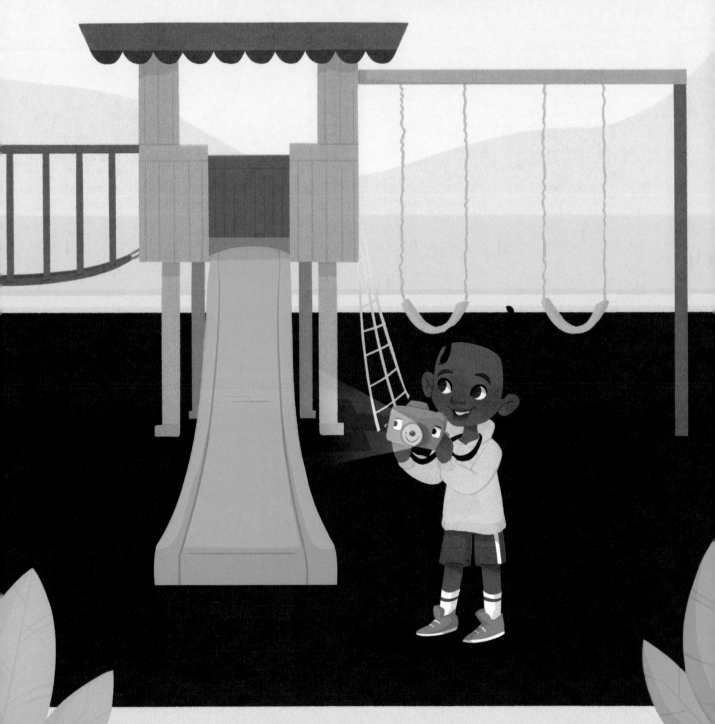

Tape a picture of your
playground here

Like Taj, find a mirror
and snap a shot of yourself.

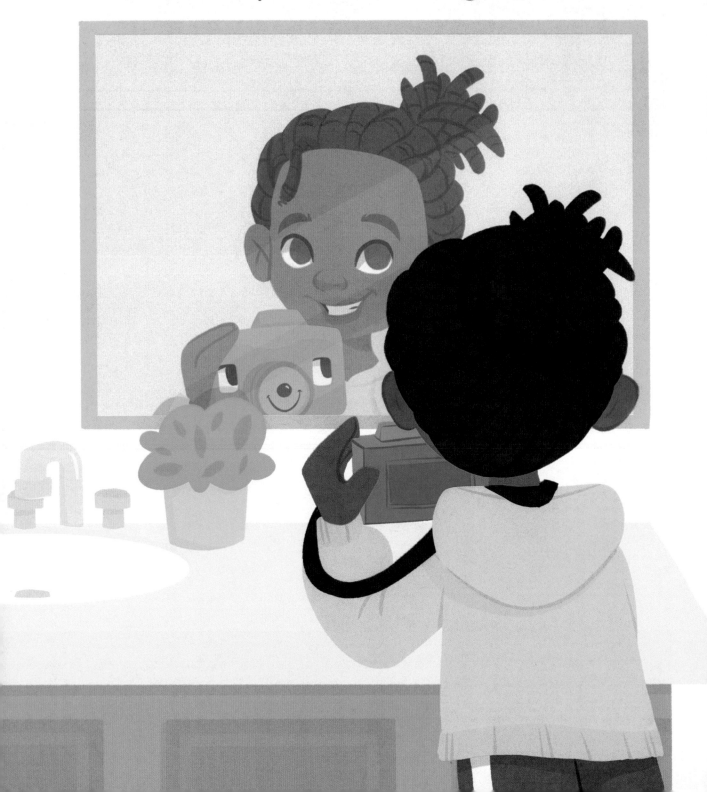

Tape your
self portait here

You did it!

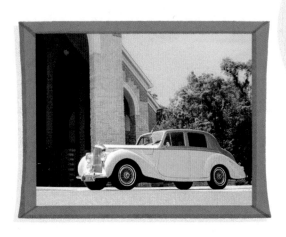

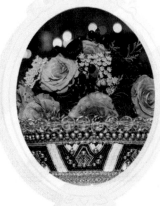

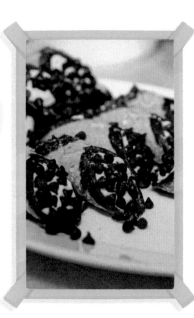

You and Taj completed your mission of taking 10 photos.

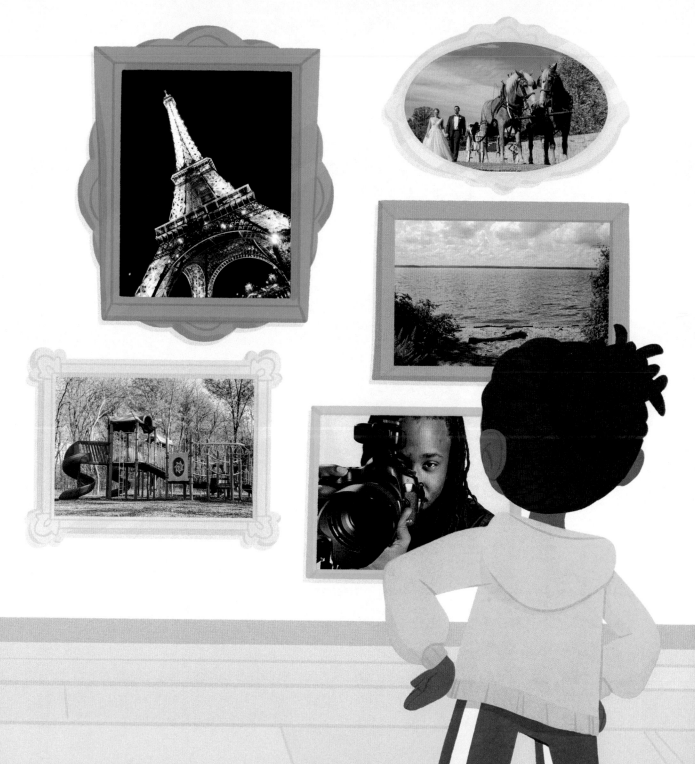

About the Author

CJ Reaves became an author during the 2020 corona virus pandemic. He is a self-taught photographer, videographer, and a volunteer athletic coach in his community.

He was nominated and honored as a top 5 photographer by Loudoun Times-Mirror, 2020 Best of Loudoun

Photo Citations:

*Home/buildings - Photographed in 2020
Buildings in Reston, Va.

*Something Red (TANKER) - Photographed November. 3rd, 2020
Sterling, Va. Red Tanker from the
"Sterling Volunteer Rescue Squad Station 25"

*Vehicle - Photographed in 2020 at Wedding In Loudoun County, VA.
Ole Skool Rolls Royce

*Flowers/Tree - Photographed in 2019 at a Wedding.
Wedding Flowers

*Food - Photographed in 2020 at a baby shower in
Loudoun County, Va. Baby Shower treats

*Tallest Building - Photographed in May 2016 Paris, France.
Eiffel Tower

*Nature/Animals - Photographed in 2020 at a Wedding at
Salamander Resort & Spa
2 Horses & a Carriage

*Playground - Photographed November. 3rd, 2020
Blue Playground at Potomack Lakes Sportsplex

*Body of Water - Photographed in 2020
Leeslyvania State Park

Made in the USA
Middletown, DE
20 July 2021